Colorin

There are so
about colori
part has to b
Colored pencils, markers,
watercolors, gel pens, puffy
pens, crayons—there are so many
exciting materials to try. There's
no better feeling than getting
comfy in your favorite spot with
a coloring book and a rainbow
assortment of beautiful markers
(or gel pens, or watercolors, or
freshly sharpened colored pencils!)
in front of you. Choose materials
and colors that reflect how you're
feeling. Colored pencils are
delicate and markers are bold.

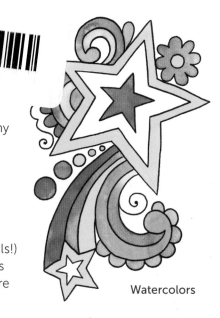

Watercolors

Whatever mood you're in, go with it and have fun on
your coloring adventure. Consider mixing two or three
different mediums in the same design to create your
own unique effects. Anything is possible on the page!

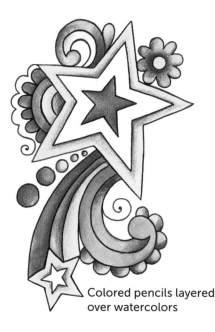

Colored pencils layered
over watercolors

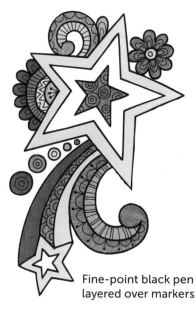

Fine-point black pen
layered over markers

Express Yourself with Color

Color can be a great way to express yourself and define your mood. When you sit down to color, ask yourself, "How can I use color to express the way I'm feeling?" Sometimes you might even feel something you can't quite put into words, but you can express it with color.

On the opposite page, I've included 20 of my favorite palettes. Each one is paired with the emotion that best describes how the color combination makes me feel. But keep in mind that everyone is different, and that's what makes art so exciting. I love to use bright colors, but maybe you like more subdued colors. My "relaxed" palette might be your "cozy." There is no right or wrong when it comes to color!

Use these palettes as a starting point and see how they make you feel. Try customizing the palette to reflect your taste and style by adding or taking away a color. Then, make your own page full of your favorite color palettes.

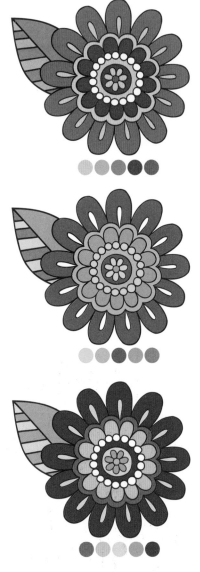

Notice how changing the color palette gives the same flower a completely different feel.

A Spectrum of Emotion

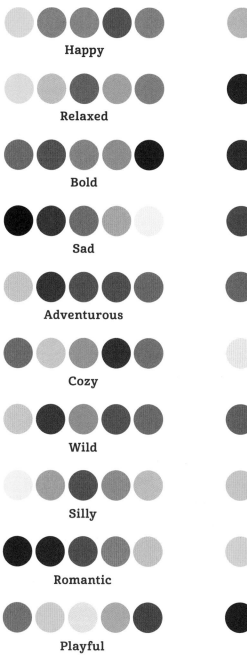

Happy

Calm

Relaxed

Mysterious

Bold

Thoughtful

Sad

Cheerful

Adventurous

Serious

Cozy

Dreamy

Wild

Sweet

Silly

Excited

Romantic

Beachy

Playful

Quiet

How to Use the Color Palettes

You'll see two color palettes on each colored example page, one at the bottom and one along the outer edge. The palette at the bottom shows the design's main colors in the large circles. The small circles show lighter colors (called tints) and darker colors (called shades) of those main colors. This is to give you the feeling of the palette and visually show which colors are dominant in the design (the bigger the circle, the more dominant the color).

Along the outer edge of each page, I've included a palette with each individual color shown separately so you can easily match your marker, pencil, or paint colors to the colors I used.

Whether you use one of my palettes or create your own, always be sure the colors you choose reflect who you are and how you're feeling. Have fun on your coloring adventure!

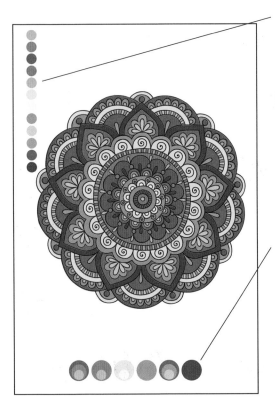

The circles along the outer edge of the gallery pieces show you each individual color I used in that particular piece. If you like the palette I chose, you can use these circles to match the colors of your own pencils or markers.

The circles along the bottom of the gallery pieces show you which colors are more dominant in each design. The larger the circle, the more dominant the color. The smaller circles show tints and shades of a main color that were introduced for variety.

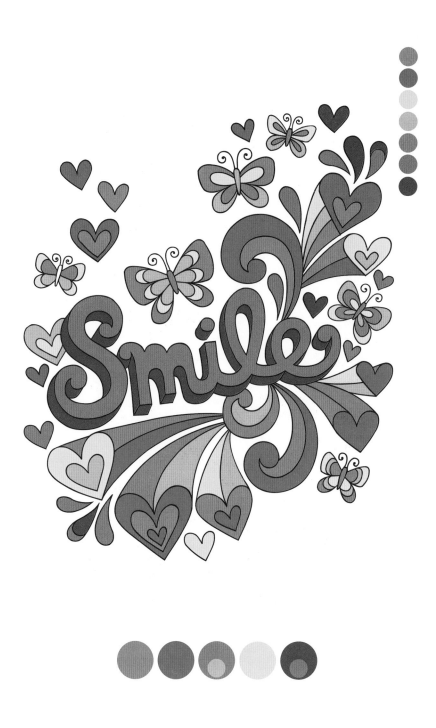

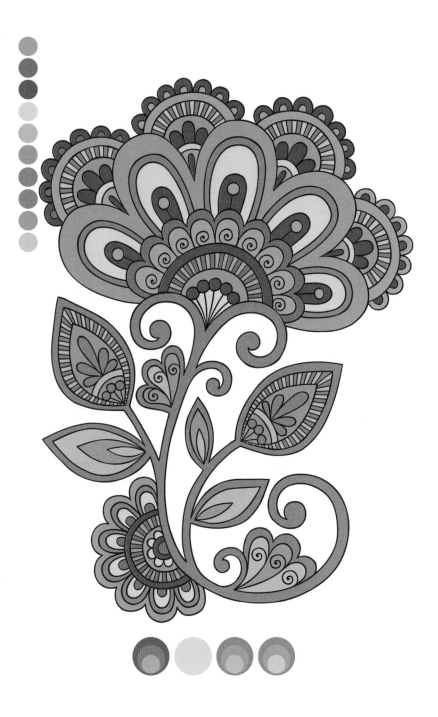

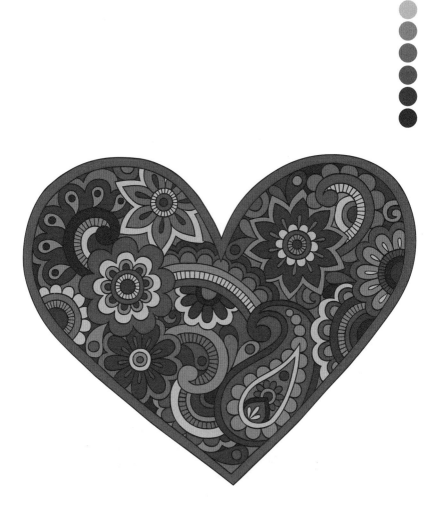

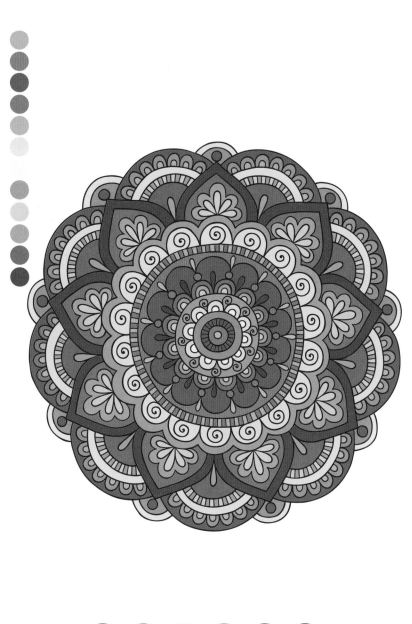

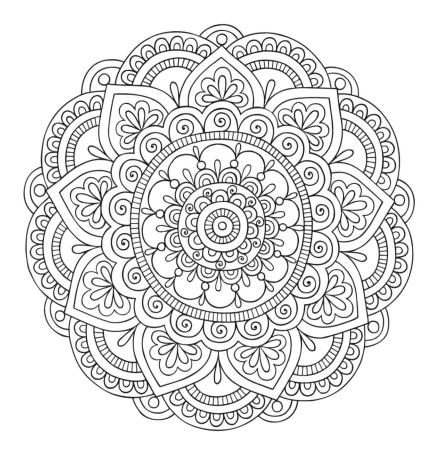

If you obey all the rules, you miss all the fun.

—Katharine Hepburn

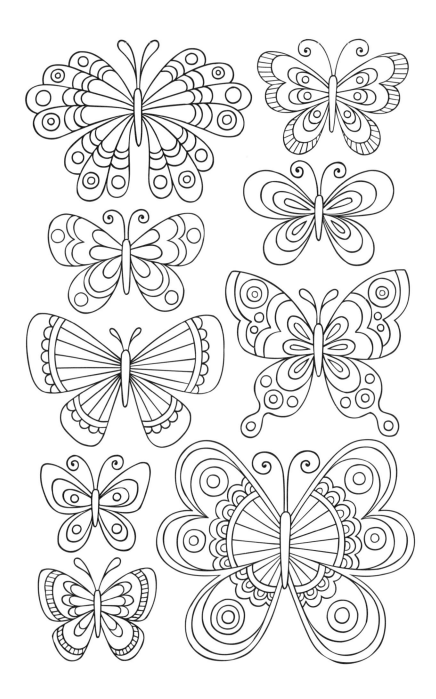

Too much of a good thing can be wonderful.

—Mae West

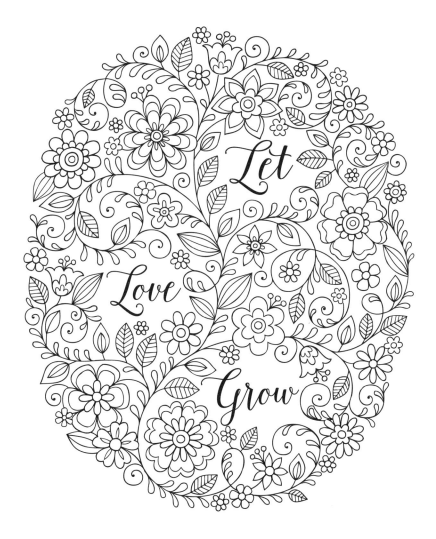

Let

Love

Grow

Being happy never goes out of style.

—Lilly Pulitzer

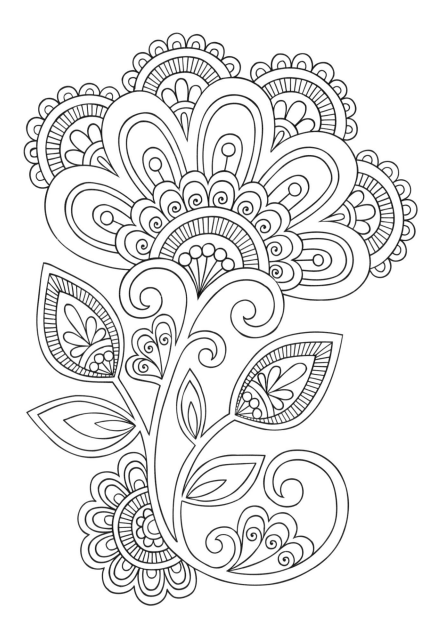

Happiness blooms from within.

—Unknown

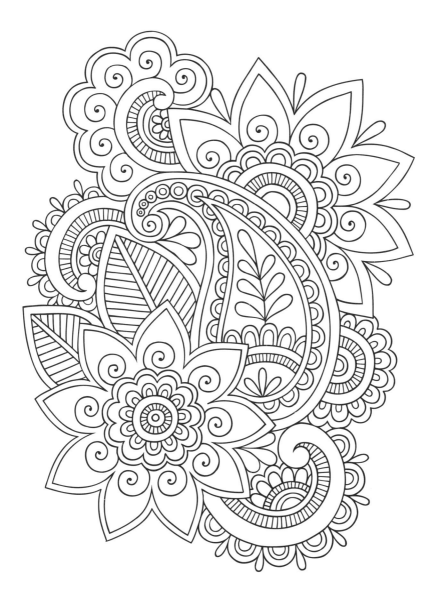

Make each day your masterpiece.

—John Wooden

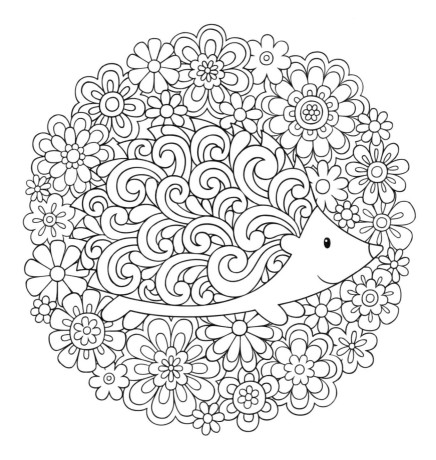

Be kind to everyone, including yourself.

—Unknown

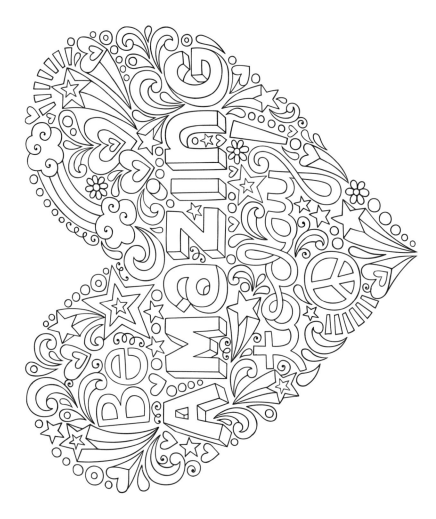

Be brave enough to live life creatively.

—Alan Alda

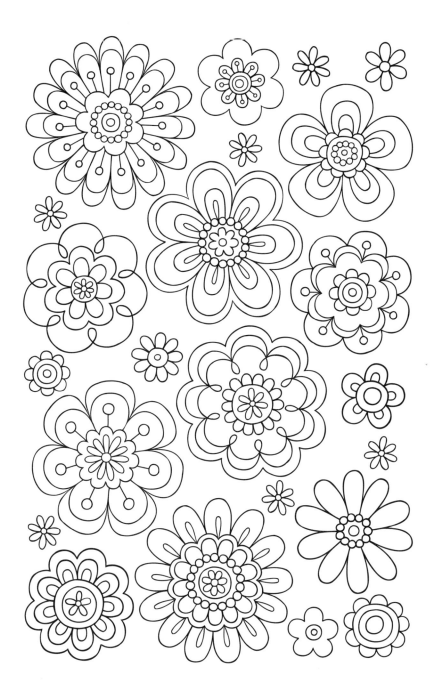

Leave a little sparkle wherever you go.

—Unknown

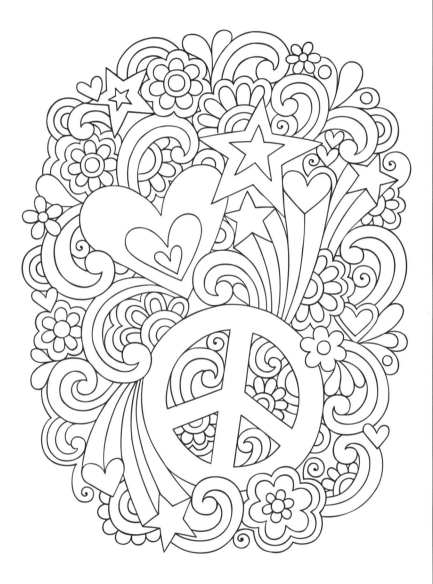

Breathe in peace; breathe out love.

—Unknown

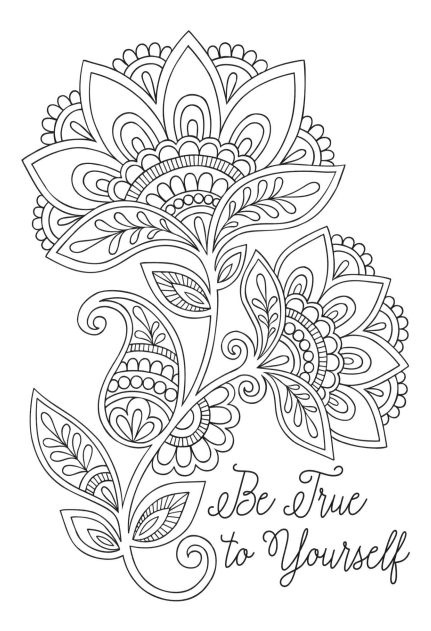

Be True
to Yourself

Live your beliefs and you
can turn the world around.

—Henry David Thoreau

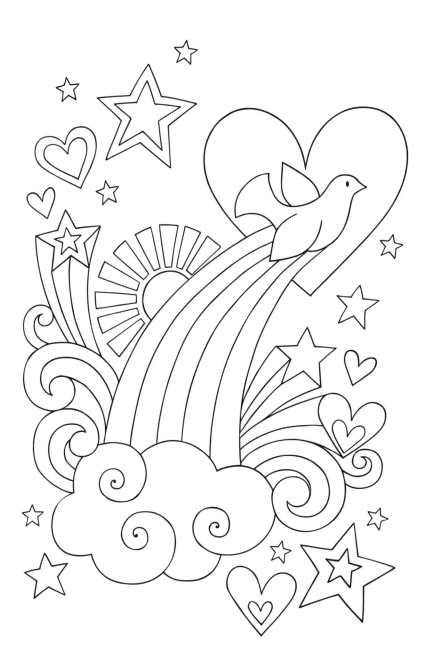

Peace begins with a smile.

—Mother Teresa

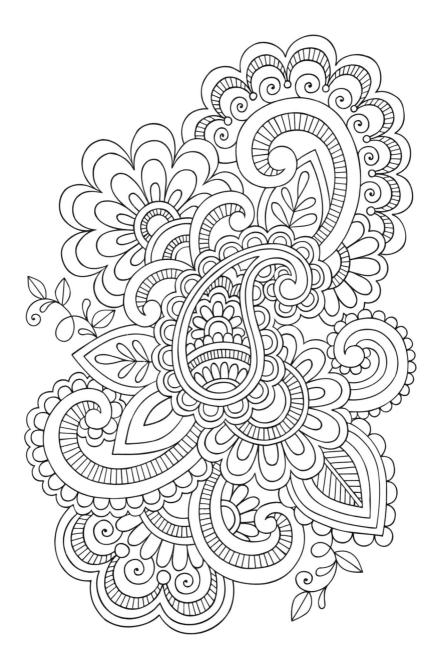

Life does not have to be perfect
to be wonderful.

—Unknown

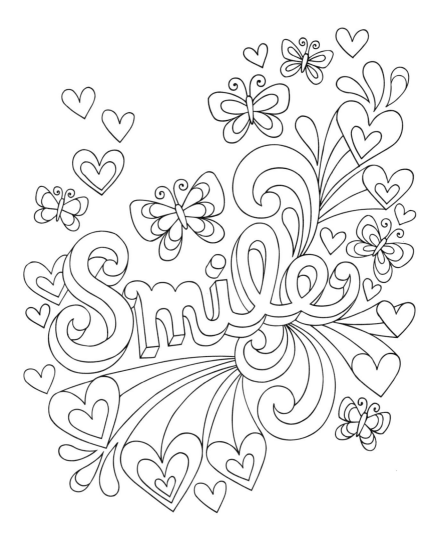

Let your smile change the world,
but don't let the world change your smile.

—Unknown

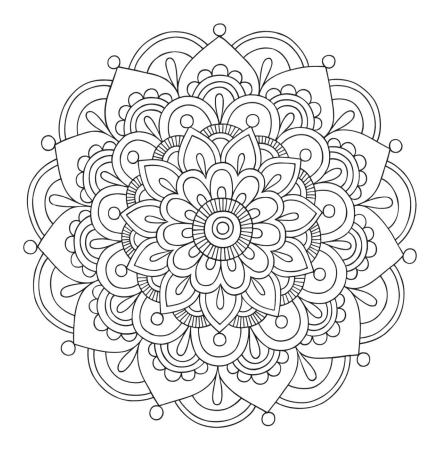

Whatever you do, be different.

—Unknown

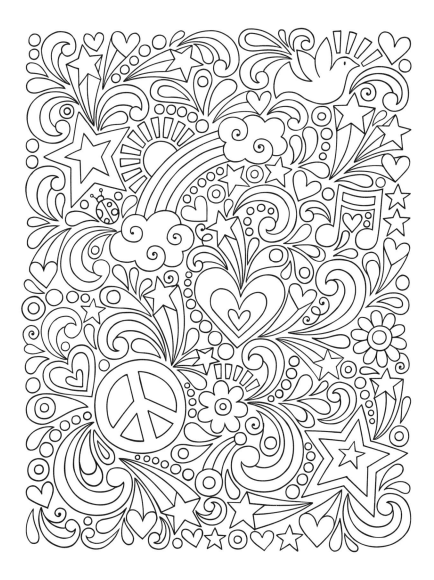

The things that we love tell us what we are.

—St. Thomas Aquinas

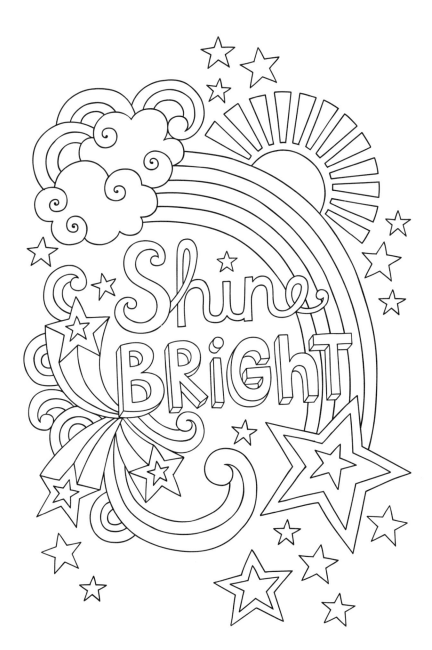

Never dull your shine for somebody else.

—Tyra Banks

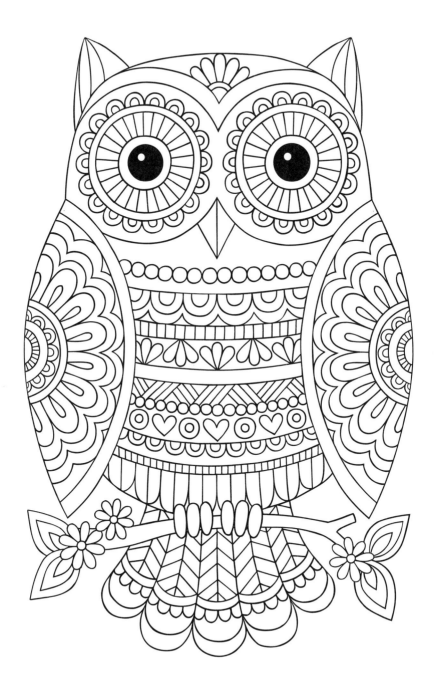

Always try to be a little kinder than is necessary.

—J. M. Barrie

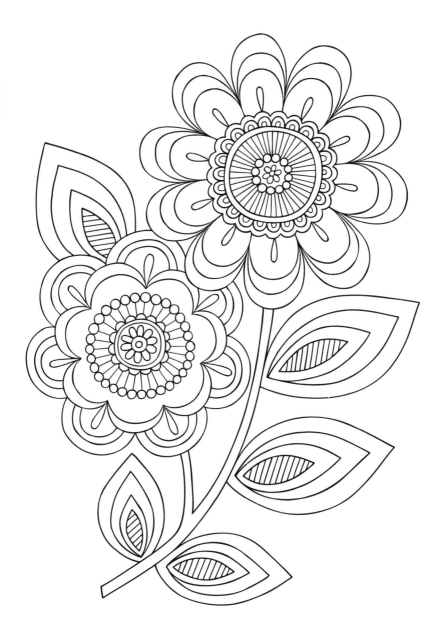

Why fit in when you were born to stand out?

—Unknown

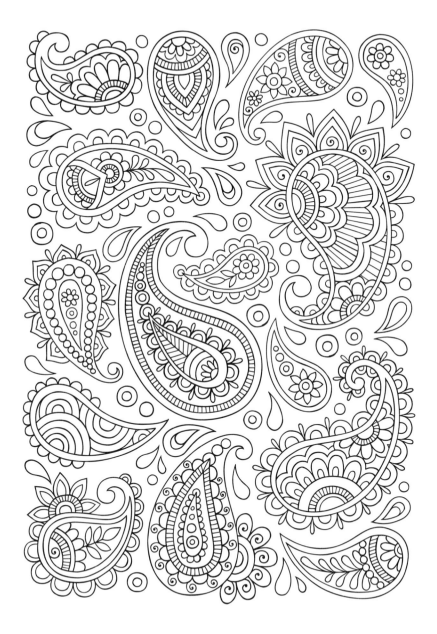

Life is a great big canvas,
and you should throw
all the paint on it you can.

—Danny Kaye

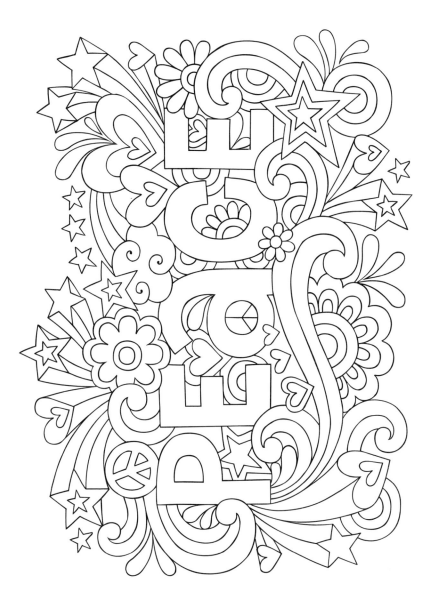

Peace is always beautiful.

—Walt Whitman

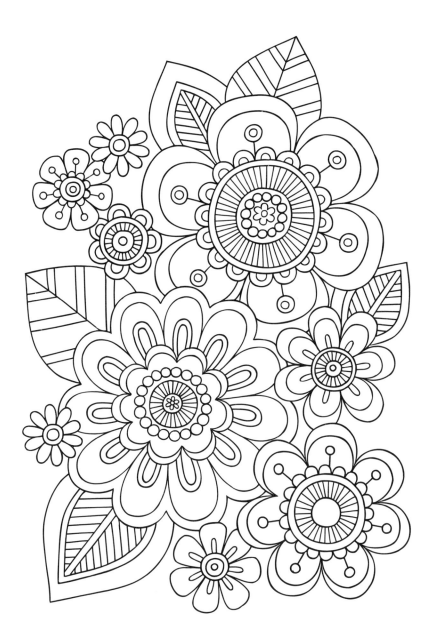

Bloom like a flower; unfold your own beauty.

—Debasish Mridha

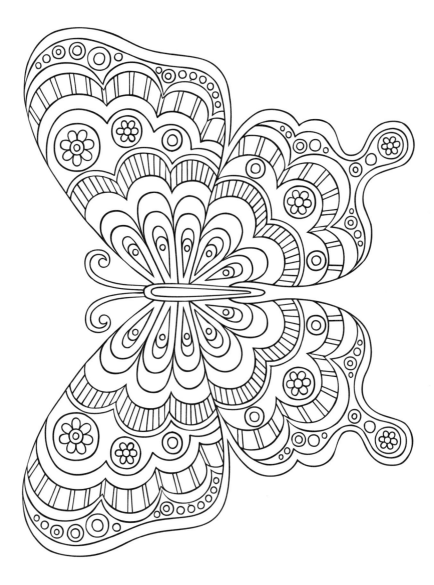

Create what sets your heart on fire
and it will illuminate the path ahead.

—Karma Voce

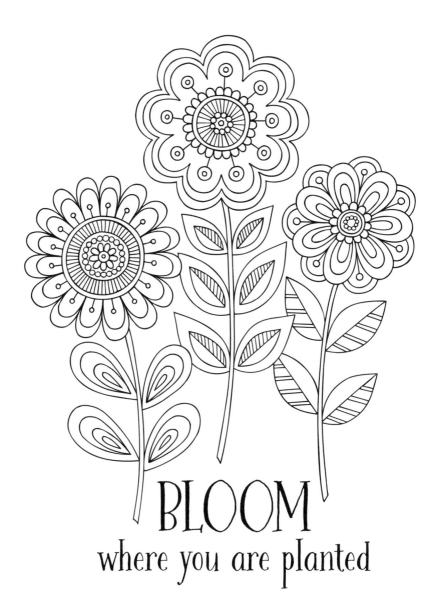

BLOOM

where you are planted

Flowers don't worry about how they're going to bloom. They just open up and turn toward the light, and that makes them beautiful.

—Jim Carrey

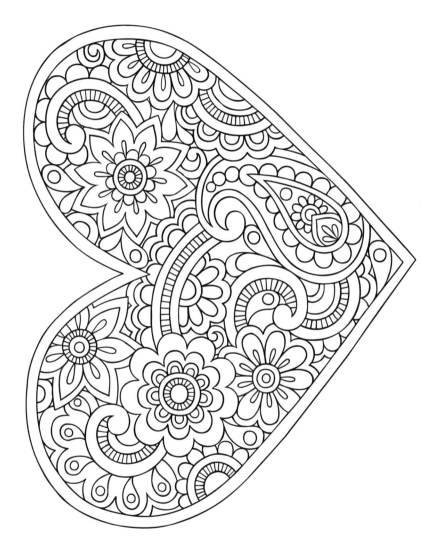

Do anything, but let it produce joy.

—Walt Whitman

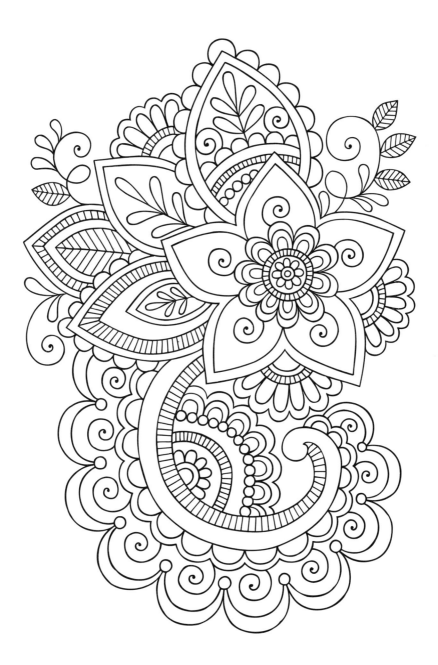

Laughter is timeless, imagination has no age, and dreams are forever.

—Walt Disney

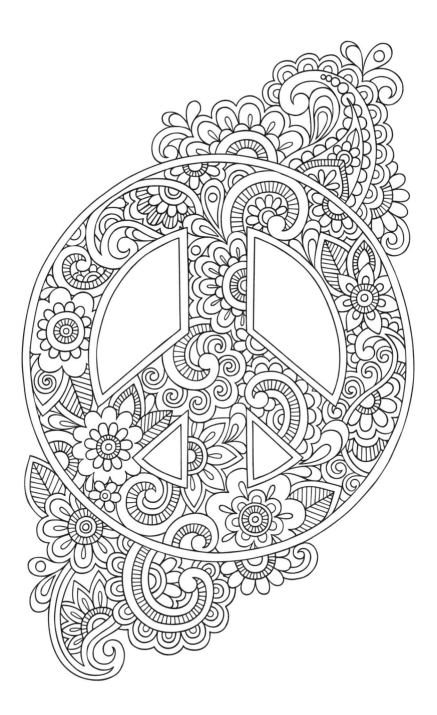

I want to feel as free as the flowers.

—Unknown

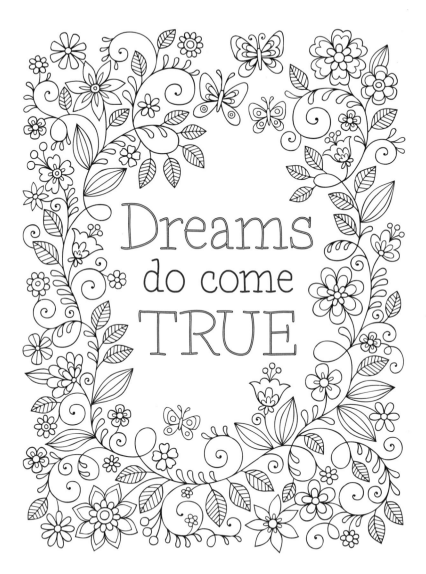

Dreams do come TRUE

We must have perseverance and
above all confidence in ourselves.

—Marie Curie

‑‑‑
‑‑‑
‑‑‑
‑‑‑
‑‑‑
‑‑‑
‑‑‑
‑‑‑
‑‑‑
‑‑‑